on endings

This paperback edition first published
in 2019 by Delere Press LLP.

First published in 2019 by Delere Press LLP
www.delerepress.com
Delere Press LLP Reg. No.
T11LL1061K

ISBN 978-981-14-1456-5
Layout By Yanyun Chen

Contents

Notes on the Oblivion of Desire

Allison Grimaldi Donahue

Note:
all translations of *Awaiting Oblivion* (italicized in Allison Grimaldi
Donahue's poem) come from Maurice Blanchot. *Awaiting Oblivion*. trans.
John Gregg. University of Nebraska Press, Bison Books, 1999.

No one here wants to get involved in a story.

bad romance:

a poem needs a pedestal

how many repetitions are required for a sign to be constituted

a succubus comes and leers into your ground floor apartment again and i won't be there for the call

i dream i bring you to meet bifo and we sit drinking sulfuric water and sweating off our expensive concealer

language, to be useful, is either redemptive or worn-out

you knocked my head against the wall. you said: the limit is there to be overreached

a grown man in brooklyn asked me if, since i live in rome, i speak romanian

king louis the 14th comes out of the beaux-arts academy in lyon with a coven of lesbians

swiss cheese is delicious, i will grate its holes atop my spaghetti

every time i cheat i get a rugburn

the claw-like wooden arm

i love a lack in communication

The language of attraction, heavy, obscure language, saying everything where everything is said, language of shuddering and of space without spacing. She had told him everything because he had attracted her and she had attached herself to him. But attraction is the attraction toward the place where, as soon as one enters, everything is said.

i put out a personal ad seeking rough sex, quoting sappho

a dream woman motionless in plaster, still managing to smoke a cigarette

she orders mcdonald's on a touch screen but won't eat it waiting for the train (the ritual)

there is still an absence of a discourse around female anal eroticism

in the rain you run down from the basilica and your pradas break, as if to be surprised

there is a strode pleasure in perpetual childhood

a real woman has a snakebite scar

an allusion to delusion walks across the room

the over-explanation of how my dead mother looks like rita moreno

around you i am always pac-man hungry for something i can't put a ticker on

the halt of realities available to each of us, a car in the middle of the cross-walk

in trieste there was a sunset and a boat

They both searched for poverty in language. On this point, they agreed. For her there were always too many words and one word too many, as well as overly rich words that spoke excessively.

But it is the farthest distance that is close.

when you stopped smoking i would begin again to maintain symbiosis

the sheets were always damp and perfumed

once we built a fountain over looking st. peter's

i call you and tell you new york is tame now and i'm smoking a juul

pearly oats for a latent love

your thumbs are like hammers folded into pockets

help me to feel coddled not rotten

with a tongue as thick as a fig

fingers pressed into a fat thigh

i don't understand you, but your words are touching me, nonetheless

11. Teeth are the bars of a prison window.
The soul escapes through the mouth in words.
But words are still the body's effluvia,
emanations, weightless folds in the air
escaping the lungs and warmed by the body.
Jean-Luc Nancy, Corpus

But the words always signal a betrayal. Always speaking for me and not often enough with me, words and body find it difficult to align. Desire's language is never honest with me, I can never see to it, not even to myself. Trips me up—each time I desire I know I could be desiring something, someone else, but then, it is too late.

in my nascent middle age, with my thumb, with

my fist, with my eye: i beg desire to stay still, if not motionless.

meeting you: the accident i didn't have

I know myself to have a compulsive desire. It isn't a sign of health. Never able to figure out what is pulling me from here to there aside from the language of it— the newness. Desire: the only emotion. Jean-Luc Nancy has a word for what we follow: "religion of touch." Touch always leaves us with the potential of danger: the danger of never touching again.

i cry on the slow train to napoli, past latina, past

it's embarrassing how my howls are primal like mozzarella

i begin to ask so many questions that are really more like demands

why isn't anyone talking about the springiness of a food? a good food may be a food that resists.

rennet is from the stomach, is from the intestines.

my memories are all buoyant, come in three colors: green and grey and white.

there is also orange, but we save that for happier times

while we wait to pierce and be pierced

That is the beauty of attraction: you will never be close enough and never too close; and yet always held and contiguous to each other. Because if we aren't separated, we cannot touch, we cannot touch ourselves except by detachment. "Thus the eye moves into the tips of our fingers and we forget the cold surface and the comparison to painting. We don't see anymore. Instead we feel tender skin, a round knee, the pleasant cheek, the beautiful breast and hip, in short, the beauty of the body." Writes Johann Gottfried Herder in the 18th century. Nothing Changes. But not to see does not always mean to touch—the space can widen.

chicken and bees and potato salad and that sour wine, how we would talk for
hours, my mouth exhausted, using the language of the last man

my mouth sour from mid-morning wine keeps trying to kiss you

a foreign language creates more space for desire because we are waiting to
understand

 but we never do

in the garden there are endless bees and as you attempt to protect me

i am run off the dirt road and into still water

Maybe some of us think in depths and others think in temporal dictionaries. My words don't move across space but rather, across time. I remember that time at the lake I learned *ovvio* instead of *obvio* from years of bad Latin. At another lake with a different lover I learn *nachtschattengewächse,* nightshades. My first word in a chain of forgotten nouns. I scan my brain in search of words and feelings I once knew only to find traces, if not traces, scraps. Even a fragment would be too whole. These are colors and sounds and tastes of a person I've now forgotten. The word is a place I will never return to. "Between life and death we become other to ourselves." Cathrine Malabou, *Ontology of the Accident* slowly these words turn me into someone I would have never understood. The reality of wanting things once unnamable.

this childhood waiting ends repeatedly but not

raining down in pneumatic coughs, this syrup sweet cherry

these pretzels giant salt crystals replicating like a disease on my lemon tree, bark
beetles and sugar

old kettle corn from a country carnival

all the corn-tossers
dead

Over the years what we communicate becomes incommunicable outside of the tiny closed circle. We find it more and more possible *in a single language always to make the double speech heard.* It doesn't matter in which language we speak because eventually, then, the circle closes even to us. On the phone, nervous, I misplace syllables forming non-words, you form laughter.

i drag my fingers along these rocks left by catullus and think what a dickhead he
must have been

original fratboys basking in the lake lights of como

damp thunder-soaked air

even the birds aggressive and needy

word from the coast arrived only on his seventh birthday
changing perception completely

the latent desire of forgetting. Until I see you I forget how I want you. *The silent walking, the mute, closed space where desire wanders endlessly.* I've always been like this, only child, lonely child. As I let it move, it bangs up against itself until it finds a vent, a crack, a fissured pipeline. Hoping to be chosen, filled, fulfilled. Just how I feel, waiting and never awaited. Perhaps the definition of loneliness. It is pathetic. How I wish I could leave you behind. The physical act of rejecting desire becomes less and less possible with time, not more so. As if my machine is broken. Ariadne knocks her bent elbow against her bent head; crooked cranking tired bones.

we sit in the sunlight and lean into the smooth contours of one another's faces

we spill bottles of feelings and paw at sadness and sand

there was a sink you pissed into in 2007 and told x his sister was too fat to fuck

it smelled like windex and poppers
it smelled like pennies and burger king

i've always been a liar, better than you

the time of thinking the best is to come has now finished, the velvet curtains are so heavy

they smell of sandalwood and glue, both too strong, too acute

"Desire: the fascism in all our heads." Deleuze. I bore even myself. Here I am, in a state of waiting for my next desire to hit. A reader without her next book, I long for longing. Lost and ill at ease without it. Caught between these regimes of signs, as if to make a choice. As if that choice would make a definition. "Under the skin the body is an over-heated factory, and outside, the invalid shines, glows, from every burst pore." Beckett, *Malone Dies*. This mess is so frothy beneath the veneer.

the cut through the pomegranate the nails bitten down but never enough

to avoid piercing the soft liquid sac

and again i've sliced the pomegranate open you

 for your own tongue i have pulled apart my fingers flesh from flesh

how will i learn this is what i am meant to hear? having spent all my years out of
tune

sitting on a couch with people i never even liked
i remember the glowing heterosexuals and my inability to forget them

some bodies glow indefinitely

moonlight and howls out of back allies and windows

radios playing incomprehensible modernist cello

and the screaming light above someone else's stove

each time there is a lover there is a loss

your hands and feet big too big: they dangle

because the first words say everything I go back and look at all of our conversations and see where I first went wrong. I should have been afraid then, at knowing you. *As soon as one waited for something, one waited a little less.* Yes, for it all to be over. To find the sweetest end. To this love, for death. I am constantly put or putting myself in this position. I end everything but I am also completely unable to end anything. Jean Marais floating across a brick wall into the underworld.

every poem is a love poem, i've always wanted to write that story

i stopped being a club kid in 2007 when i fell asleep
on the subway

riding back and forth on the j train scuttle

our power dynamics both classic and contrived

wanting i am never read in my own hand—

if this were good luck i would have to wash it off

i make friendships based on beauty and cry about it

stupidly and incessantly spending all my time
on love

Don't I remain here only so that I can efface all of the traces of my stay? A deep breath, I want to take it all back. I think there is a crux. My blood makes a flowering anemone of me, solid to the sea's surface. *They were both dreamed only by the one they would have liked to be for each other.* Pulling the other from the lesion in the coarse bark. This longing brings cuts and bruises when it is finally dislodged.

the new year of the disenchanted. and if you didn't contemplate your fleshiness enough

the way yr so pink and spurling

the way i twirl my fingers in my bush

push on the mons, relax my kneecaps

fist fucker with a cigarette in the other hand

leans into me to make a question

there are days when my whole body hurting my legs limp of rush

nylons to make women pliant, there is no doubt

Something negative helped her speak. He had the impression that in each of her sentences, she always made room for the possibility of finishing. It is in this space therein lies the possibility. It is where past and future will also meet. The broken bone, the fissure, the crack in the wall. See Agamben *it is the contemporary who has broken the vertebrae of his time* or see Cohen *There is a crack in everything. That's how the light gets in.* for further exploration of the fissure. See where the turning of past meets future and I cannot twist to the appropriate angle. "Desiring-machines work only when they break down, and by continually breaking down." Delueze. Our only future is in our disrepair.

mina, mina, and those gay painterly fabrics

desire, desire, and waiting to speak

without all organs except the tongue: language tied to the land or language tied to movement

yes. a choice

my pagan roots keep rooting here, under this hot sun

we took our bicycles into the thunderstorm and plowed over wet trees

i came home bruised one side whole, lightning struck a barn in the backyard

scoldings made memorable by their paucity

You will never find the limits of forgetting, no matter how far you may be able to forget. Forgetting comes in different phases, each one associated with a different sensory memory. I walk into closets and sniff. I listen to old messages and trace the writing on postage heavy envelopes. Taste stews gone rotten with freezer burn. Gaze at photographs with the hope of eye contact. *She forgot more slowly than slowness, more suddenly than any surprise.* This is the widest fear: always remembering the wrong thing. *Writing in the direction of forgetting.* It changes and flees each time. To write a love story, to put it in the immemorable past.

sitting at a small righthanded desk i cannot end a

sentence so put me in a corner and watch the words

climb up a wall, see the anxiety of ants in the prep school

atrium, climbing climbing up itchy plaid kilts,

indistinguishable from the everyday itch-fest

Could desire be attached to forgetting. i am forgetting myself in order to desire you.

i am desiring you in order to forget myself.

though touch cannot be situated in any specific sense organ i try with each. the repetition makes for few surprises, even when expected.

He wonders if she does not remain alive so as to make the pleasure of ending life last.
"How ugly, the happiness we desire. How beautiful, the unhappiness we have."
A.H. from Jean Cocteau *Orpheus.* Greedy in my wants and wishes.

what i remember upon meeting you

like garlands and folds

upswept hair obscuring and

stuck to your damp face

turning to curls in the humid roman winter

a mix of chill with fever

an undrained bath slowly unheating

it's odd how reassuring i find

the human form

thousands of years have failed to alter

breasts and kneecaps

long-jointed fingers and toes

ignorance relates us to each other as long as we stay this way there is a future: a future in which desires can never not unfold. Hope springs eternal, whomever in my childhood said that? Curse them.

god's hot hot breath on me

he likes to have his nob cast

sex sex sex

i would not take bread from the hand of that woman

carnifex

take hold of the altar

humans may be more predisposed to respond to

situations that involve agents

See: X-Files
See: Lesbians

The characteristic of the room is its emptiness. Please, let me polish your poem with pumice. I hate to beg but you can sense my desperation. The room is beautiful this way, no furniture could possibly suit it. My body, my loneliness can spread and fill it and still keep its space.

The wearing skin
The brush
The grain
The steel wool pulled across knuckles

Dirt is a social construct. I find it under my nails as we replant the basil. The undertaker was always an unwelcome sight but we both laugh as the hearse drives by. Only such polluted hands could insight such war. I knew I wouldn't be the one drunk, crying, squat in a fountain.

my childhood fear of slipping on

the third rail persists

i slip on wet metal

as the sun shines

you laugh and i long

to feel something like

that anger ever again

the way my fingers grip to the grates
the way my shoes wedge between the squares

To wait, to make oneself attentive to that which makes of writing a neutral act, coiled upon itself in tight circles, the innermost and outermost of which would coincide, attention distracted in waiting and returned all the way to the unexpected. Waiting, waiting that is the refusal to wait for anything, a calm expanse unfurled by steps. A place where no one would ever improve. I stick out my hip to give you my pocket, not my head, but my chin down left brow up right, yes say to help me move these stones from one pocket to the next. This exchange can be our dance.

a widow is a veil
a marble fold
keeping warm

and other preciousness

the swan. her feathers
to melt and make
the philosopher's stone

"earnestness and hard work are to be regarded with suspicion" Sarah Lucas on a card at the New Museum. You and your big erasure poem. The sound of the thickest magic marker. Smells good, like a Tuesday at the bar. I am always bent over and burning hard pressed and still full of pulp. "BRITOMARTIS: I don't understand you, beautiful Sappho. Desires and restlessness made you who you are;" Pavese, *Dialogues with Leucò* "then you whine…"

driving for hours north of the city to find you

living in a world of big dix and crushed metal

there is a town— vestal, full of dark bars and rolling hills

in the back of a garden, hidden even to the regular customers

small statues

what is the relationship of ash to softness?

Desire is not a song banging around in my head or in the streets.

Waiting imperceptibly changed the statements into questions. <3

east river rolling over my eyes and winter

steam from my own breath and dumplings

stuffed with green vegetables and spice

while we wait on line you you explain everything

to me even before we've had a coffee

or spoken to our mothers and the phone uptown

sitting on their respective roofs sunning under
 their respective suns

the paradox of wearing a night mask on the sunniest day of the year

to stop a headache you need to be well-equipped

a sound mind, discovered with a tuning fork

indeed prone to rust and wearing

leaving traces of lead and iron across

the dry creases of unwintered hands

still touching, soft in their weathered passions

"I see everything that you have said around you"

Jennifer Hope Davy

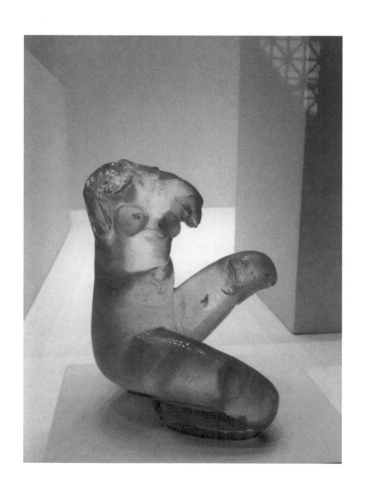

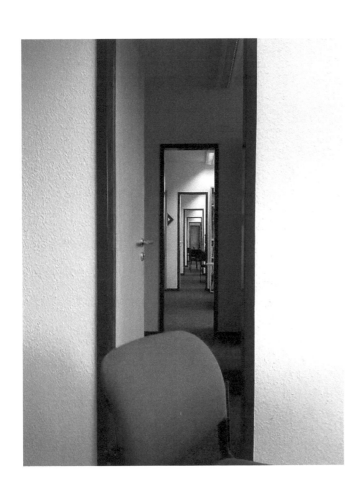

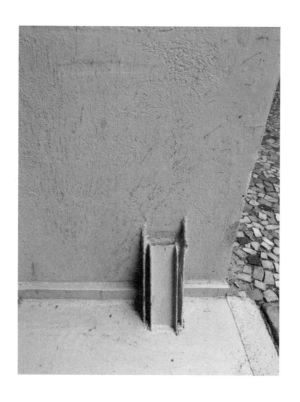

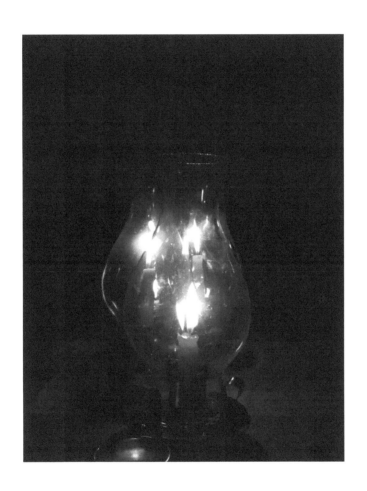

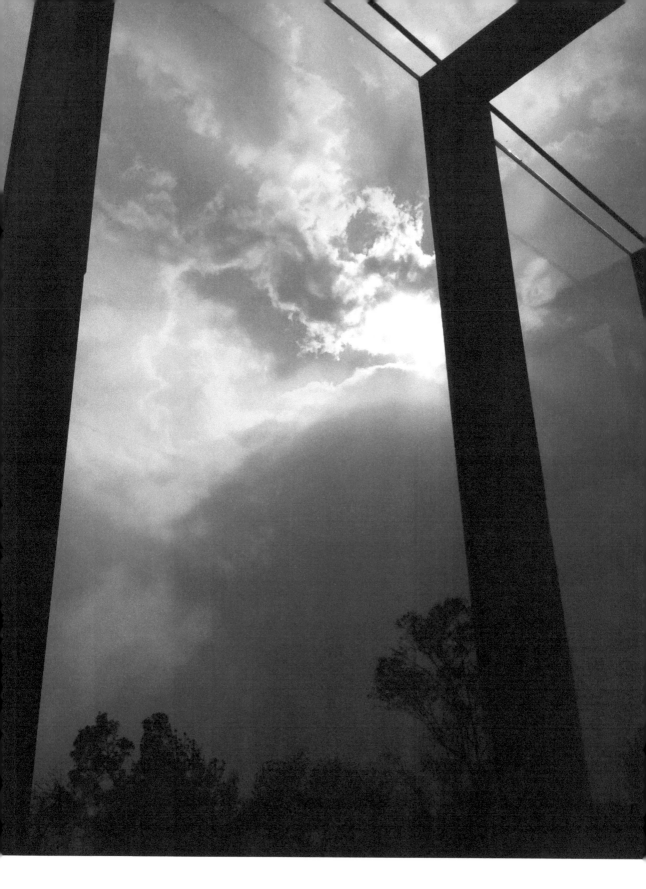

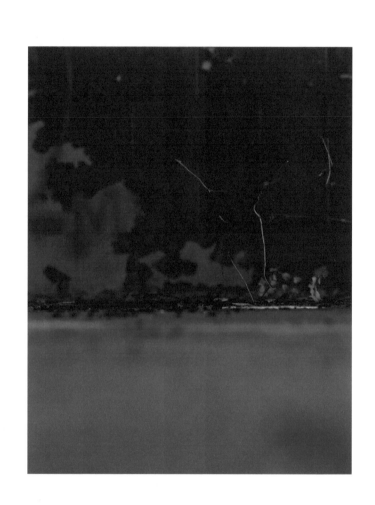

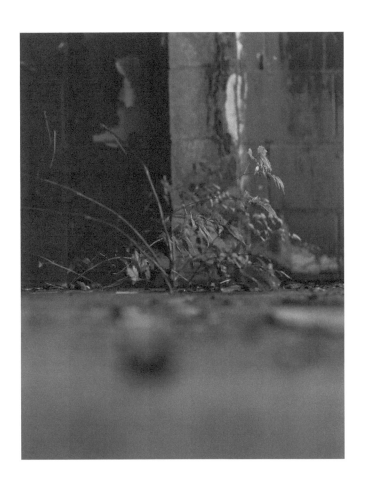

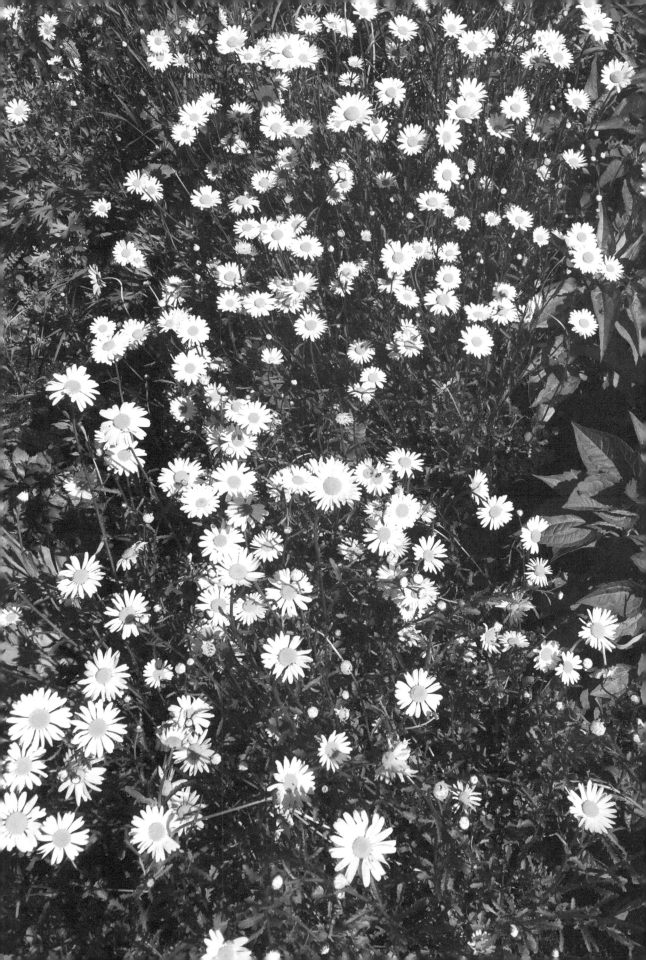

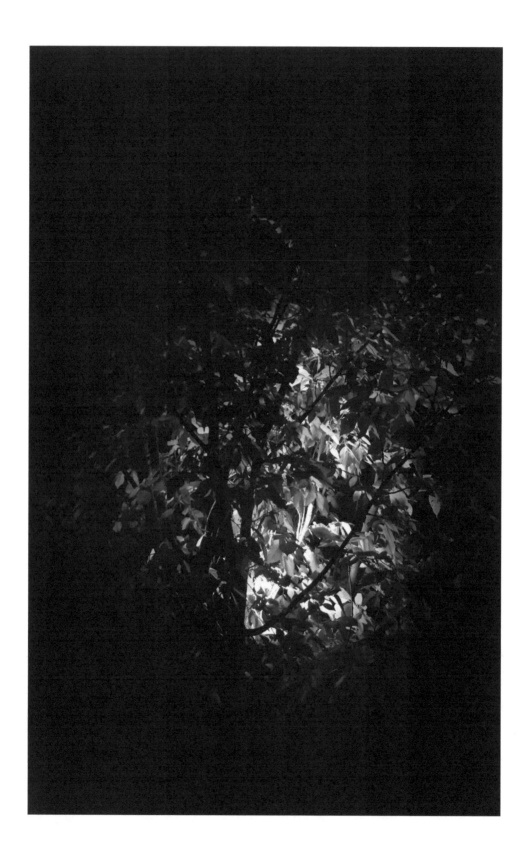

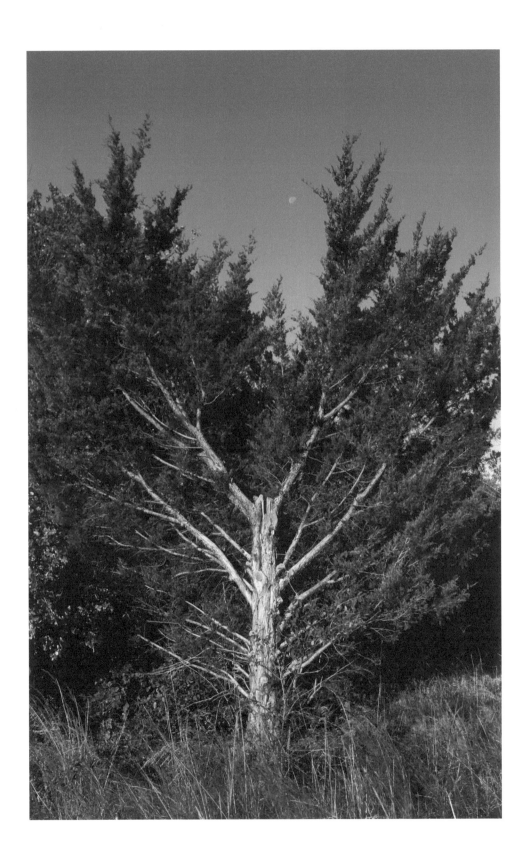

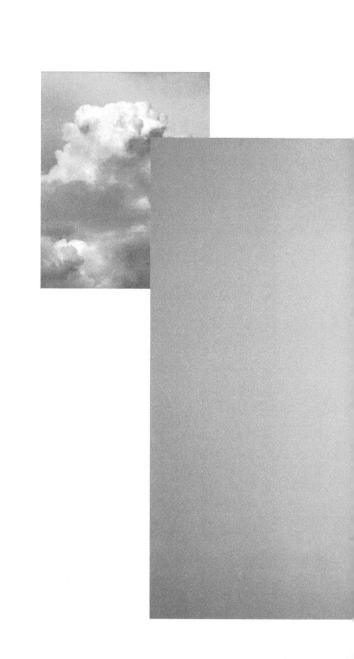

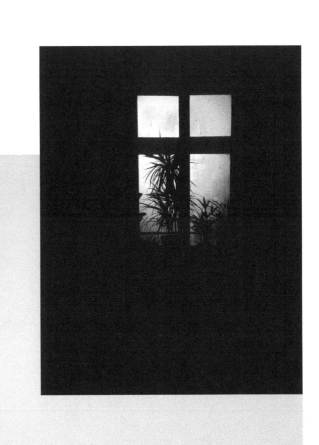

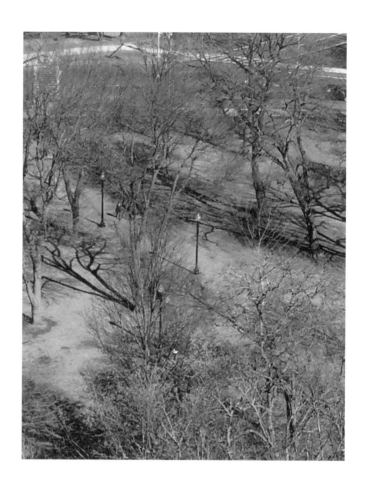

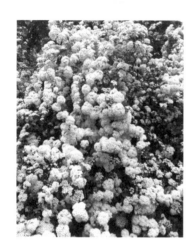

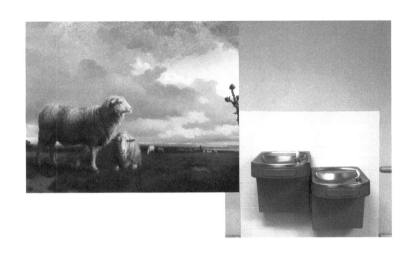

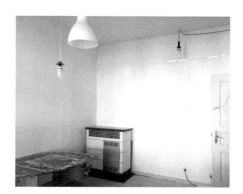

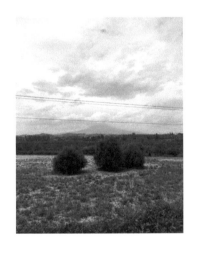

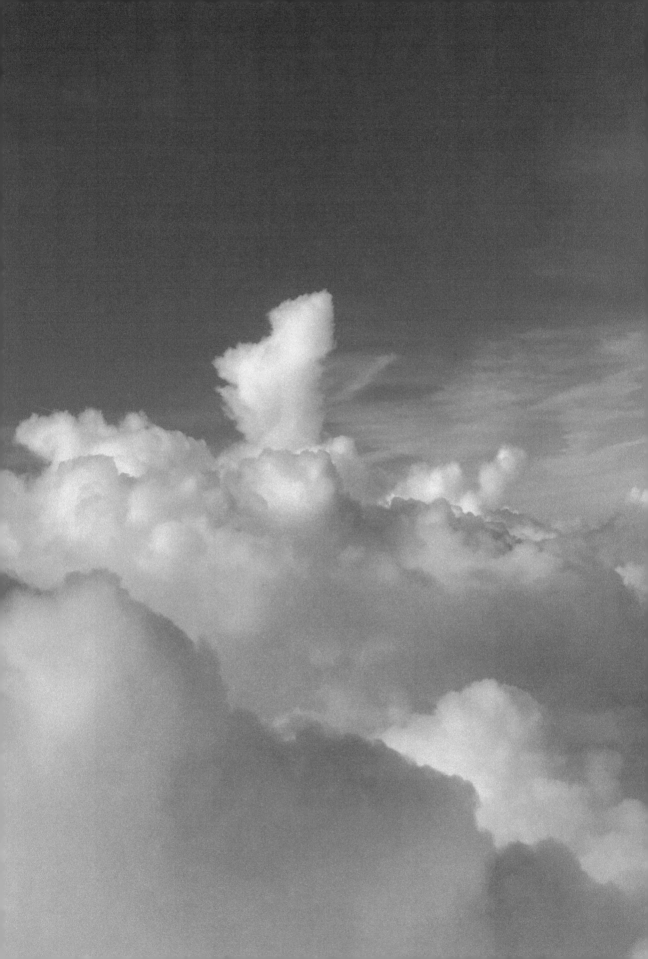

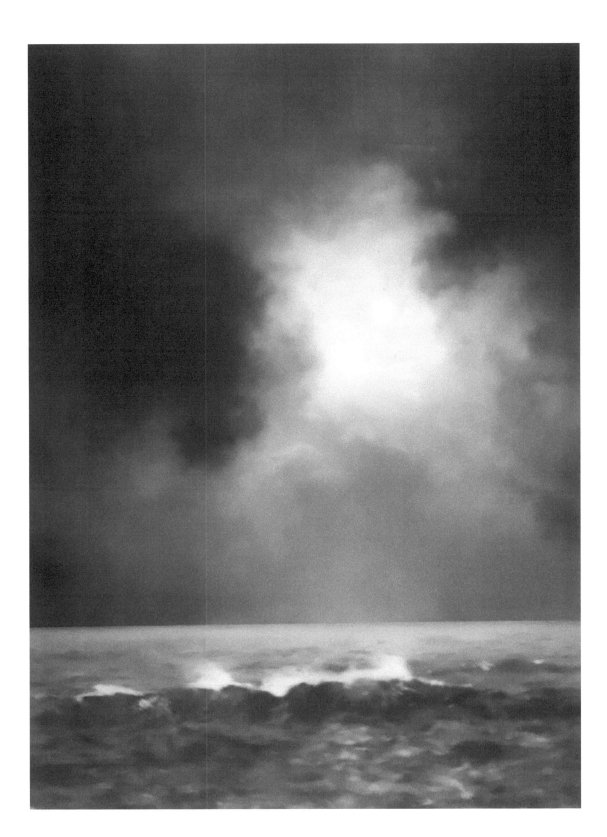

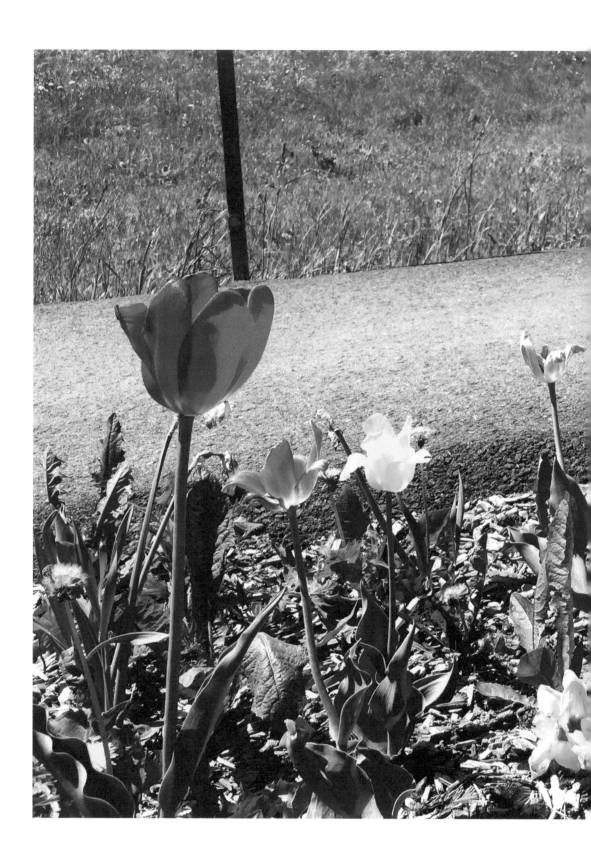

Image List

ENDINGS

Julia Hölzl

Note:
All quotes in footnotes are taken from
Maurice Blanchot, *Awaiting Oblivion*, University of Nebraska Press, 1997.

also:

[—and all this a/s writing-with, a/s writing-with blanchot
(no/t dialogues, but a/s conversation)

not to answer
that is,
that is to say
with blanchot

awaiting, a waiting, as waiting
for it is here, perhaps,
that

etc

nothing is to come
each time,

that this [is]

that there is an end to time

such end: never a/s such
to say an end is, then, to say its ending
each time]

RE-VIEW[1]
and all these turnings yet to come

for, after all,
where should she turn to

for, after all,
how to re-turn, how to turn back
how to turn, how to turn one's back to turning as such

nothing to begin with

PLUS[2]
but then

he was waiting for a past that never came,
yet still
everything remained untouched

having passed, always yet to pass,

all the same she came

plus ça change, plus c'est la même chose
i know

more of the same, each time
each time, the same remains intact

and yet everything remains unchanged
such is its ending, such is its each time

1 "* There must be no turning back." (8)
2 "* And yet everything remained unchanged." (13)

ETERNITY[3]
the moment: such is its each: such is its always.

in a way it is us who end: each time, each time and every time,
[who is the *we* in and of such us]

eternity: the nobility of absence
noblesse oblige,
not yet

the no longer of here

the end, never an is,
the end does not elude eternity
but twits its toward

eternity must end

EXPRESS YOURSELF[4]
leave it unexpressed
leave it as if
as if

let us not say this end. let us remain silent.
"Silent upon what?"
"Upon the fact that silence has a tone"
"If silence has a tone, then how to speak it?"
"Speak it by not saying it."

as if
madonna was listening

3 "* We must always, with respect to each moment, conduct ourselves as if it were eternal and relied on us to become ephemeral again.
They always discussed the moment when they would no longer be here, and although they knew that they would always be here to discuss such a moment, they thought that there was nothing more noble about their eternity than to spend it evoking its end." (16)
4 "* Express only that which cannot be expressed. Leave it unexpressed." (16)

HUSH[5]
the daylight of existence points us nowhere
a/s clearing
(no *Licht-ung*: no/t Heidegger)

the fluid comportment of being
points us elsewhere,

it is at dawn that endings occur. –
that being takes its place
that endings come to pass

never a/t present, never through light,
and no obscurity, always *untertags*,
(to bring into) the light of day is where

we can only imagine this end to end

it is in the passing of words that language comes to pass, comes

she missed her.—

SAME SAME[6]
the end/ending/ending/s/to end, same same,

more of the same, she was indeed tired of relation

nothing compares
in and to the end, nothing compares

nothing compares

5 "* Through the words a little daylight still passed." (19)
6 "* He did not think that one utterance had more importance than another; each one was more important than all the others; each sentence was the fundamental sentence, yet they attempted only to gather all together in the single one among them that need not have been proffered." (23)

SAME[7]
still seeking a contrast

each day a/s same day, eternal recurrence of dawnings yet to come
it is always a same day passing by,
each and every day

 "Which day"?
"The same day"
 "How can two days be the same?"
"They cannot."

toward each passing
the passing of sameness
the passage yet to come

EXTENT[8]
nothing at all
if that

absence, the vastness of presence
such is its extent
such is its dimension

to lose oneself in absence
narrow its appearance
narrow its abode

7 "* The same day was going by." (26)
8 "* Narrow the presence, vast the place." (30)

OUT-WITH[9]
they stepped out of presence, each time

each time
a/s tres-passing of time

time is an end, always,
time ends, such is its ending

the end is no end in itself
the end is not
[is]

finite traces

he would leave

PART/ING[10]
no end is near

such might be what binds us,
perhaps

9 "* A hurried, eternal step." (39)
10 "'Perhaps we are separated only by our presence." (42)

EX[11]
she kept speaking

ELSEWHERE[12]
[am *ende* sein, am ende *sein*]

but

that such end
takes place
for the end to take place
the end: a/s might, a/s perhaps

of course, if

ONE WAY[13]
or another
and another

where to depart from, and why

why did she ask this question
"Because I insist on the absence of place"

how to reach

11 "* She spoke, going from word to word to use up her presence." (54)
12 "* 'Is it here?'—'Of course, if you are here.'—'But is it here?'" (59)
13 "* It is as if they still had to look for the road that would take them to where they already are."
(64)

NO FUTURE[14]
the future finally as such

when does it begin, where does it end
why does it, then, present itself

she thought herself without a future; she did not think herself at all

she thought herself without a presence
she did not wait for

PASSAGE[15]
the future is absent, and yet it does not come

TRINITY[16]
go for it, she said,
let us go for it

from which it led them nowhere
in,to nothing

she was still wandering
seeking the point of no return

14 "It is death, she said, the forgetting to die that is death. The future finally present." (43)
15 "* 'Does that come to pass?'—'No, it does not.'—Something, however, is coming.'" (81)
16 "* They went, motionless, letting presence come.—Which, however, does not come.—Which, however, never already came.—From which, however, comes any future.—In which, however, every present disappears." (84)

NO[17]

for (how) to end an end
and what if
what if this were

that the end was nothing given
but that the end is what is *gives*

sometimes she remembered

"Why forget what could not be"
"Forget, do not obliviate"

she had imagined the/ir endings to be different
not different, but altered, always transformed

not as something *to end*
but as some thing ending

[there is nothing outside the end]

coming to an end

she had seen it coming

17 "* That which escapes without anything being hidden".(42)

Allison Grimaldi Donahue is a writer and translator whose work as been featured in a number of journals and magazines, including *The Literary Review, BOMB, The Brooklyn Rail, Mousse, Public Seminar, Tripwire* and *Words Without Borders.* Her poetry book *Body to Mineral* was published by Publication Studio Vancouver in 2016. She holds graduate degrees from Middlebury College, The University of Toronto and Vermont College of Fine Arts. She lives in Rome, Italy where she teaches creative writing and literary theory.

Jennifer Hope Davy is an artist and writer whose practice centers on the overlooked, the everyday, and the murky space between cognition and visibility. Recent exhibitions and readings have been with miss read at House of World Cultures (Berlin), Tulsa Lit Fest, Philbrook Museum of Art, Massachusetts College of Art and Design (Boston), and FARM Cultura Park (Sicily). Recent published works include *Pedestrian Stories,* (Delere Press, 2014) and *[Given, If, Then] A Reading in Three Parts* (Punctum Press, 2015). She also has contributed essays and reviews to various art journals and catalogues. Davy received her BFA from the San Francisco Art Institute, her MA from the University of Texas (SA) and her PhD from the European Graduate School (CH), where she is also an advising fellow. Currently, she is in residence with the Tulsa Artist Fellowship where she is completing an audio play and photography collection, and beginning a novel. *Staging Aporetic Potential,* addressing staging and potentiality in critical theory and contemporary art, is forthcoming.

Julia Hölzl is an independent theorist and "thesis therapist" whose work tends to revolve around finitude, transience, and ending/s. She holds a PhD in Modern Thought from the University of Aberdeen as well as a PhD in Media and Communications from the European Graduate School (Saas-Fee/Switzerland), where she is also a Fellow. Julia has taught on a variety of topics in the humanities and social sciences at institutions in Austria, Germany, the UK, Thailand, and Hungary; most recently, she worked as a postdoctoral researcher at the Academy of Fine Arts Vienna. Latest publications include: "Horror vacui ('That nothing is what there is')" [in: Matt Rosen (Ed.), *Diseases of the Head: Essays at the Intersection of Speculative Philosophy and Speculative Horror,* punctum books; forthcoming), "A(s) Step Not Beyond: Blanchot's Écriture Fragmentaire" (Belgrade Journal of Media and Communications; in print), and "A Scandal for Thought" (FKW // Zeitschrift für Geschlechterforschung und visuelle Kultur, 63/2017).

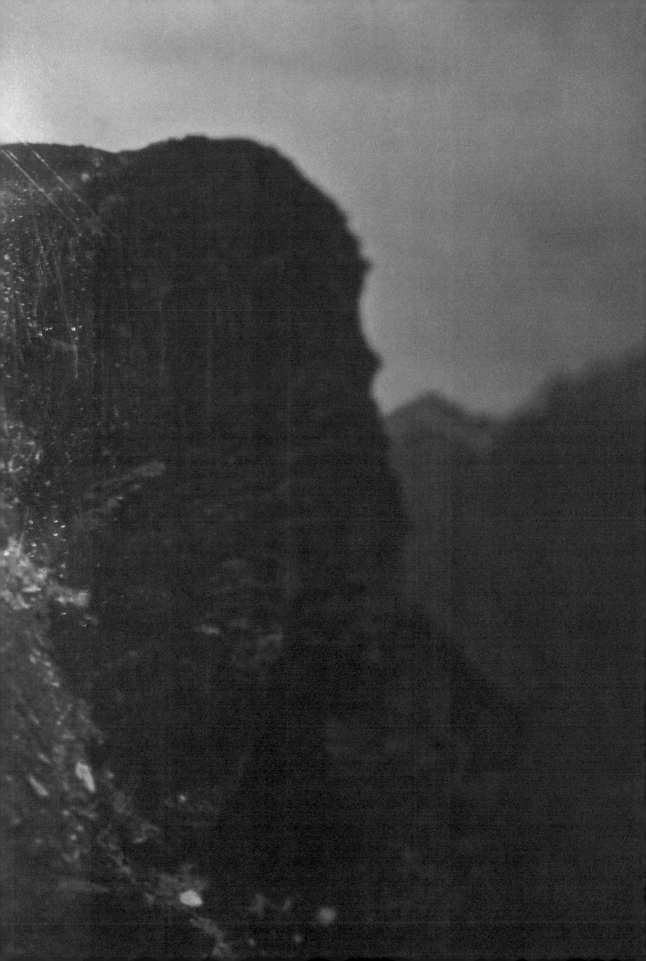

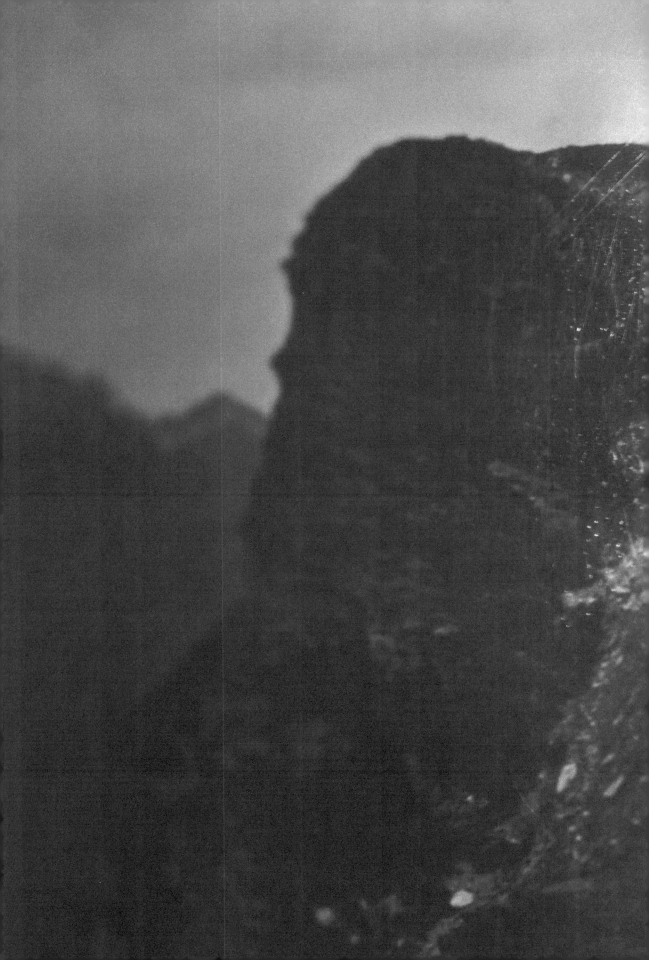

CPSIA information can be obtained
at www.ICGtesting.com
Printed in the USA
LVHW072352200720
661147LV00004B/167